GAUGUIN'S
NOA NOA

© 2003 Assouline Publishing for the present edition
601 West 26th Street, 18th floor
New York, NY 10001, USA
Tel.: 212 989-6810 Fax: 212 647-0005
www.assouline.com

Translated from the French by Shaun Whiteside
First published in Great Britain in1996 by
Thames and Hudson Ltd, London

© 1995 by Editions Assouline, Paris 1995
Photography by RMN, Paris 1995
Jacket illustration by Editions Jan Forlag, Stockholm, 1947

Color separation: Gravor (Switzerland)
Printed by Sing Cheong (Hong Kong)

ISBN: 2 84323 562 6

GAUGUIN'S NOA NOA

MARC LE BOT

ASSOULINE

*NOA NOA is an
expression in the language of the Maoris,
whose ancestors inhabited Polynesia long before
the Europeans ever set foot there and took possession of it.
NOA means "perfume", NOA NOA "very fragrant",
and it is this expression that Paul Gauguin
chose for the title of this book.
The painter wrote the text of the book by hand.
This was in 1894, during the few months he spent in Paris
between two visits to Tahiti. Later, from 1896 onwards,
he repeatedly returned to the manuscript, adding new
texts to it and, most importantly, adding pictures:
watercolours and woodcuts.*

i t was Paul Gauguin's intention, through his images and words, to reveal what his two stays on those far-off islands, the first in Tahiti alone, the second in Tahiti and then in the Marquesas Islands, had brought to his art and to his way of thinking. The book's title captures the essence of this: the painter's physical, intellectual and emotional adventure among these people in this exotic land had, for him, the profound, sensual, heady charm of a perfume. Although the text was produced before the pictures, the latter cannot be said merely to illustrate the text. In fact, the opposite would be closer to the truth. Certainly, the painter's primary wish was to tell the story of his visits to the islands. First of all he wanted to use words to explain the intellectual benefits that he had drawn from his experience. Was he not the first European artist to have lived in a distant country in order to discover the culture and customs of one those peoples who were commonly called 'primitive' or 'savage'?

But, as we flick through the pages of NOA NOA, we can easily imagine what happened. When he returned to his text in 1896, his new task of writing prompted the painter to think in images as well. Re-reading it and adding different ideas, he set down his

pen and picked up his brush. And as we look at the pictures painted on the pages of the manuscript, they tell us much more than the words do. They speak with greater intensity, not only of the sensitive and sensual relationship that the painter's eye had established with the people and things of this distant country, but also of the artistic ideas that those people and things suggested to him. This is because a painter thinks with his eyes. While he is thinking/painting, words may come to his lips or they may come to his pen: a visual sensation might find an echo in the words formed by the lips; or, in the case of Paul Gauguin, in those heady perfumes that, during his stay in Paris, returned to him from the depths of his memory. In any case, Gauguin was writing in order to talk about painting. His words are there in order to help interpret his visual thinking. The age was one of a battle of ideas, the battlefield being the newspapers and magazines. For this reason, Gauguin was always writing – not only the many letters he sent to his friends, and the notes and reflections in his diaries, but polemical texts written for publication. NOA NOA was just such an essay that dealt with art and culture.

Where art was concerned, the end of the 19th century was to be a period of bitter arguments. For Manet, Monet, Gauguin, Van Gogh and Cezanne, it represented the birth of a new king of art. It came under furious attack because it was itself the radical critique of a secular tradition, and was therefore obliged to defend itself with equal vigor. Paul Gauguin's response to these arguments was an extremely tense one. Along with Van Gogh, it was his art that had the worst reception. But he talked and wrote a great deal in order to bear

public witness to his artistic convictions. For this reason some people called him a 'revolutionary', as he himself reports with some surprise. This surprise is a kind of naiveté; Gauguin really did liberate the painter's art from academic traditions, which had become ossified and out of touch. The painter had to become once more what he had been before: someone who cast an innocent eye on the world, not to mention the distant worlds being discovered by colonial adventures. NOA NOA is testimony to that ambition. But clearly words did not adequately convey that testimony; why else would Gauguin have painted on the pages of his manuscript?

t he book is an unusual object: a collection of pages hand written and painted in watercolour. How could an object such as this reach its intended audience? How could it be printed in a large edition in an age that lacked industrial methods of colour reproduction? The story of this bound notebook testifies to the difficulties faced by the development of modern art. The painted manuscript was, as an object, to go through many adventures, some of them unhappy. But fortunately it was to some extent saved by the friendship and admiration for Paul Gauguin of Georges Daniel de Monfreid, the painter, and by Victor Segalen, author of *Les Immémoriaux* and poet of *Les Stèles*. Segalen, a military doctor, was the first to hold the actual manuscript in his hands. Towards the end of 1902 he was sent to take up his post on a ship in the fleet based in Papeete. From his youth, the young doctor had been a passionate lover of literature and had now begun to write. He was already keeping company with figures from Parisian literary circles, such as Rémy de Gourmont, who

suggested that he try and meet Gauguin, at that time living in the Marquesas. Many poets and painters in France recognized Gauguin's genius and were concerned about him, as his paintings were selling very badly. Since he had begun to paint, he had lived constantly on the brink of poverty. His departure for the Antipodes, the severe difficulties that he encountered there and his poor health were all, in fact, cause for concern. At this point, in 1902, Gauguin maintained contact almost only with Georges Daniel de Monfreid, who was not even living in Paris. Neither Rémy de Gourmont nor the others were aware if his state of neglect and were ignorant of the violent hostility shown him by the Marquesan authorities. Segalen would not have the chance to meet Gauguin in the Marquesas, as the painter died on 8 May 1903.

However, Segalen devotedly collected all the traces and mementoes of the painter that he could find. He visited his house, 'a tall Marquesan shack, with a thatched roof, mounted on stilts'. He describes its outside, where, facing the door, there was a kind of idol that Gauguin had sculpted in clay; inside, emptied of its furniture, figures painted on the walls surrounded the inscription: 'the house of ecstasy'. There were also a few other objects and paintings scattered around the studio.

Later, back in Papeete, Segalen was present at the sale, brought about by bankruptcy, of Paul Gauguin's goods, and acquired several works. It was thus that he came by one of the two manuscripts of *NOA NOA* – the one the painter had brought back from France, first to Tahiti and then to the Marquesas, in which he had made additions to the text and in

which he had painted. Segalen describes it thus: 'It is a volume of [white] pages, everything written on Ingres paper folded in quartos and sewn by the author, whose hand took delight in everything that becomes decorative material – wood, skins, mother-of-pearl, wax and gold. The binding is supple and opens well under a tobacco-brown cover, velvety, without joins and flat-backed... The text, whose pale brown ink is in complete harmony with the browned paper, is, here and there, interrupted by water-colours – most of them on paper that has been separated, cut out and pasted. There are traces of everything which, at that time, made up the everyday life of the Master as he did battle with the merciless existence of the Tropics – the splendour of the light, hard work and renunciation.'

This manuscript is now in the Cabinet des Dessins at the Louvre. First of all, it is a copy. The reasons for the original duplication of NOA NOA tell us a great deal both about the fate of Paul Gauguin and the difficulties that modern art has faced in gaining accep-tance for its ideas.

gauguin fled Europe three times: the material and intellectual conditions of the artist's life were intol-erable for him and for his nonconformist art. Three times he sought a country where life was less expensive, and where he would find a 'primitive' culture more in harmony with his artistic project. He travelled to the Antilles, where the cli-mate did not suit him. After his first stay in Tahiti, he returned to Paris in another attempt to try to sell his paintings. His sec-ond visit to Tahiti would be his last, as he never came back.

Between his two stays in Polynesia, in order to justify the originality of his art, he decided to write the kind of manifesto that is NOA NOA. In it he explains the reasons for his exile as well as his artistic intentions. This first text he wrote at this point formed only the core, we might say, of the manuscript in the possession of the Louvre. For during this stay in Paris, from August 1893 until July 1895, Gauguin saw fit to collaborate on the definitive version of NOA NOA with his friend Charles Morice, the Symbolist poet. He felt that, as far as he was concerned, writing was not really his *métier*. He must also have hoped that Charles Morice would help him have the book published in the future. Unfortunately, he then let Morice take charge of things, which he did to the detriment of Gauguin's own work. The poet appropriated the artist's text, adding developments in a style that was quite his own, and entirely contrary to the painter's unmannered writing. He even inserted within Gauguin's personal text poems of his own devising.

Paul Gauguin would later speak of all this in measured terms, since it was true even then that a painter needed to find an echo of some sort among poets and writers. Shortly before his death he talked of his 'collaboration' with Charles Morice; he wrote to De Monfreid in 1902: 'For my part, this collaboration had two aims. It was not what other collaborations are, that is, two authors working together. I had the idea, talking about non-civilized people, to bring out their character alongside our own, and I had thought it would be fairly original for me to write (quite simply, like a savage), and, next to that, to have the style of a civilized person, which is what Morice is. So I had conceived and arranged this collaboration in this way; also, not being, as they say, myself in that line of work, in order to establish which of us was better, the naive and brutal savage or the man rotten with civilization.

Nevertheless, Morice wanted to publish the book anyway, although at the wrong time; but that, after all, does not reflect badly on me.'

Rotten it is. But it does not dishonour Gauguin that the 'savagery' which he claims for himself, and which is the mark of the Maoris whom he is praising, is opposed to what he judges to be a decadent civilization. He imagines a 'collaboration', which was really to be a confrontation. But things did not go well, as Morice tended to dispossess Gauguin of his own thoughts by imposing upon him his 'poetic' formulations. Gauguin was aware of this and in 1899 wrote to Madame Morice. He begged her to intervene and ask her husband not to modify his original text too much: 'One more thing: the book *NOA NOA*. I beg you, believe the little experience I have and the instinct of the savage civilized man that I am. The story-teller must not vanish behind the poet. A book is what it is, incomplete, whatever. However, if you can use a few stories to say what you have to say, or to hint at things, that's already a great deal. They'll be expecting some verses by Morice, I know, but if there are a lot of them in this book, all the naiveté of the story-teller disappears, and *NOA NOA* loses some of its original flavour.'

Which book? What was the original flavour that was lost? Charles Morice 'collaborated' with Paul Gauguin throughout 1894. He added 'poetry' to the 'story' that the painter wanted to make out of his adventure. Gauguin copied this revised text out by hand before leaving France for good, in 1895. It is this 'duplicate' that is in possession of the Louvre. However, after Gauguin's departure, Charles Morice

continued to add to the painter's text. In 1897 he published extracts from the book in *La Revue Blanche*, which published the work of the Symbolists. In 1901, ignoring the letter that Gauguin had addressed to his wife, he took charge of the work; on behalf of the artist, he published a *NOA NOA* with Éditions de la Plume, with the names Charles Morice and Paul Gauguin given as co-authors. In 1908, Charles Morice sold his manuscript to a print dealer, Edmond Sagot. Berthe le Garrec, his daughter, published a facsimile of it in 1954, but it was not until 1966 that Jean Loise finally published an edition using the original texts written by Paul Gauguin.

Gauguin, for his part, never ceased to work on the handwritten copy which he brought back to Polynesia, and which is thus the Louvre manuscript. There were a number of blank pages left in the volume that formed this copy, which Gauguin covered with images. For two years, from 1896 until 1898, he also included daily jottings. When he left Tahiti in 1901 to settle in the Marquesas, his health deteriorated severely. Illness prevented him from painting; he complained of insomnia, and said that he spent hours writing at night. He then added a fifteen-page text to *NOA NOA*: a pamphlet against Christianity, denouncing its role in the destruction of indigenous cultures. The manuscript of this text is now in the St Louis Museum in the United States.

NOA NOA is a work to which Gauguin returned repeatedly over the course of ten years. What was at stake here is of enormous importance in the history of ideas. Gauguin was so attached to the work because it actually affected the whole of modern art, not only his own work. Towards the end of the 19th century, we see the emergence of profound, perhaps revolutionary ideas, which affect artistic thought. We can also observe a new art being born: an art which Charles Baudelaire called 'modernity'.

During the 19th century, classical art survived, often to brilliant effect, in the work of Ingres, Delacroix and Courbet. Classical art took as its task the representation of reality. It testified to Beauty as discovered in Nature. It illustrated mythology, people's daily lives and political history. In order to 'represent' in all 'truth', this art assumed methods and rules, thus imposing a certain way of seeing the visible. We need mention only two of the principal rules: one being the space depicted, shown in perspective, which renders it measurable; the other being colour, which is subject to this same imperative: it fades into the distance, its hues mingle and blur.

Paul Gauguin, like all 'modern' artists, was to invent other rules. These artists would suggest other ways of seeing the world, which they claimed were more fully in accord with contemporary conditions of life.

moreover, as the whole world knows, there are ways of seeing other than those propagated in the European art of the classical area. Like the other artists of his time, Paul Gauguin was familiar with the arts of the Far East and was seduced by 'Japonisme'. There was also a growing interest in foreign sculpture which did not obey the rules of the realism the West had inherited from the Greeks. These statues were idols, created by supposedly 'savage' or 'primitive' people, like the Maoris, whom Paul Gauguin would soon come to know.

The Primitivist movement marks the birth of our modern art. It is easy to understand why. The arrival of the 'industrial society' wrought terrible changes on our world. How does one paint

Susanna and the Elders or bucolic landscapes in an age of colonization, and the arrival of a multiplicity of cultures on the artistic scene? What is the task of art to be in a society which entrusts its engineers with building metallic structures peopled with technical objects? It was now that Gauguin fell prey to two contradictory temptations. He reviled the modern world, accusing it of mistreating its artists. However, I would contend that his innovation lay in the way he thought about the 'modernity' of life. Nonetheless, this contradiction is not an impasse, but a dynamic force within his thought.

*g*auguin is one of those people who reveal what is really at stake within all artistic thought. Our modern world organizes its technical activities and is tempted to organize human relations primarily according to their utility. However, in order to live, human beings also need to enjoy sensuous and emotional relations with nature. The arts of all ages have assumed the task of reviving the 'unquenchable fire', which, according to Heraclitus, is vital. In their attempts to stir up this fire, to invent a new art fit for the modern conditions of life, many artists tried to accomplish something like a return to the sources of all the arts. They invoked examples foreign to our Western culture. They turned, as if to guarantors or allies, towards the 'other' arts: the arts of those peoples who, as they are not 'civilized', to use Gauguin's word, are called 'savage'. For Gauguin, this movement of ideas bore rich fruit. The painter declared himself a 'savage civilized man'. Throughout his life he never stopped trying to make contact with exotic landscapes and primitive cultures.

There is something very personal at the root of this 'primitivism'. That something concerns childhood: to seek out the 'primitive' is to seek out the infancy of human societies. But for Paul Gauguin, it also meant moving towards his own childhood. In his letters he also mentions his exotic family origins. To go in search of 'savages' was, to a certain extent, the equivalent to him of dreaming of becoming a child again.

How could one fail to be moved by this daydream? People who are attached to art ask that the works should create relations between themselves and the world that are just as vivid and as filled with wonder as those seen through the eyes of a child. An artistic image is always a new birth of the power of vision. The 'primitive' in any human being is his or her own childhood.

A daydream of childhood, a genealogical daydream, preoccupied Paul Gauguin. Through his grandmother, Flora Tristan, he was descended from a great Peruvian family. When he was three years old, his mother took him to live in Lima, where he stayed for four years. He was to have vivid memories of his time there. Later, at seventeen, he took a job as a trainee on a merchant vessel bound for Brazil. This course of action, which led Gauguin to remember his childhood, touched upon something essential to his art, but it also influenced his reasoning as an adult. The painter would always consider contemporary civilization 'rotten' and he would constantly confront it with the purity, the innocence, the 'primitive' truth, of the 'savages'.

It was in this sense that Gauguin took up the theme of 'savagery' when he decided to flee Paris to take refuge in Brittany. Brittany, for him, was not merely a beautiful part of the provinces where life was not so expensive. He said: 'I'm going there as a peasant under the name of a savage.' From Tahiti, he wrote to Georges Daniel de Monfreid; 'I am and will remain a savage'. He insisted:

'You were mistaken one day when you said I was wrong to write that I am a savage. But it is true: for in my works there is nothing that surprises or diverts except for this aspect of the 'savage-in-spite-of-myself'. That's why it is inimitable.'

In a little-known text, an interview published in *L'Echo de Paris* on 13 May 1895, Paul Gauguin explicitly stated that 'primitivism' is the childhood of humanity rediscovered. He said that art is that process of thought that will not allow modern man to forget the perceptible bonds attaching him to the world. Speaking of Polynesia and the Maoris, he declared: 'I was one seduced by that virgin land and by its pure and simple race; I went back there, and I will go back there again. To make new things, you must go back to the sources, to humanity in its infancy. My chosen Eve is practically an animal: that is why she is chaste, almost naked.'

One of the pictures in *NOA NOA*, a small watercolour, represents a Maori woman: she is naked, lying on her stomach, and her face is turned towards to us. This image is an arresting one. In it we can see something close to another version of Gauguin's famous pointing, *L'Esprit des Morts Veille* (The Spirits of the Dead Watching) of 1893. But more particularly, the picture is charged with an emotion that disturbs us. The painter, we imagine, has asked the woman to assume the pose as models do in European artists' studios. The woman has obeyed, uncomprehendingly. Her we have a body revealing itself in all his nakedness; however, it seems almost huddled in on itself, and its gaze, the empty expression of her face, seems to want to keep us at a distance. This uneasy relationship, which at

once yields proximity and distance, is art itself. All art is made in order to make intensely present the very thing that cannot be seen. To experience the feeling of beauty is to open wide one's eyes in order to admire: to prove that the real is marvellous because it preserves its mystery for us.

The nude that Paul Gauguin has painted here is a dark-hued surface, monochrome and practically without modelling, almost without any effect of depth. It is an area of flat colour which abuts another area, this one light in colour. Lower down in the picture, a floral fabric hangs vertically. There is no perspective here, no false depth, no measurable space plunging into the distance. The zones of colour, since they are without depth, seem almost to stand vertically. Thus the body, the bed and the floral fabric are equidistant from our eyes. Our only sense of space is that of the greatest proximity which tends to erase all distance. The effect is made more intense by the singular use that Paul Gauguin makes of each of his colours. They are intense because they are apparently 'pure', painted in flat surfaces, with their hues saturated with pigment. They jump out at us and are not subjected to variation, erasure, or the blurring produced by perspectival distance. They too make the visible intensely present to us, all the more so since the technique of watercolour, which makes the mixture of pigments very difficult, plays subtly with its opacities or transparencies throughout the pages of the manuscript of *NOA NOA*.

This effect of intense presence runs through the painting of Paul Gauguin, and the representations of nudes often have a heightened erotic charge. The pictures in *NOA NOA* feature all kinds of subjects: landscapes, portraits of Maori men and women, animal and human scenes. Even in landscapes suggestive of vast spaces, the depth of the field of vision is highly attenuated. It is especially so in scenes featuring people: the one with three women

sitting on the ground; the one in which the fisherman is depicted returning to his shack with a fish on the end of a line; the one with two nudes by the sea, their bright backs turned towards us, offering their smoothness to the caress of our eyes. One of these pictures represents a boat sailing on the sea, among the waves; it too is shown in the vertical, so much so, in fact, that the sea begins to assume the appearance of a backdrop.

In order to achieve these visual effects, the flatness and intensity of the colours compete with the abolition of perspectival depth produced for our eyes by a layering of horizontal strips. Paul Gauguin's œuvre is not the only one to exploit this important feature. Van Gogh, his close friend, says in a letter to his brother, Theo: 'With red and green I shall express the terrible human passions.' Paul Gauguin, like Van Gogh, like Henri Matisse, like many abstract painters, is a painter of colour. Colour, in contrast to line, is not measurable; it is beyond measure. It is the vehicle that many modern painters have chosen for the expression of the passions. The painters of colour, in modern art, are those who lay more stress on emotional intensity than on the description, however violent it may be, of the visible.

n*OA NOA* is a book that reminds us of the passionate aspect of our lives. This is the essential message that the painter is communicating to us. And we find this message more clearly, more incisively, more urgently in the pictures than in the words of the text, in which Gauguin, as he wrote to Madame Morice, wanted only to be the 'story-teller' revealing to Europeans the wonders he had discovered in an exotic country.

Many of the subjects that he close to paint attest to the violence of the emotion within him, which bound him to human beings and to nature. Thus the pictures that carry an erotic charge are well placed within his work as a whole: female nudes that have the stature of goddesses, or a man and a woman coupling in the calyx of a flower whose stylization is redolent of the medieval imagery of illuminated manuscripts.

Paul Gauguin's meditation on the human condition, when it recovers its original qualities, does not distinguish between the beauty of the body and the beauty of the soul. It opens up into a meditation even broader in range. In *NOA NOA* we find figures of gods or spirits standing or rising up in wild landscapes. One of his woodcuts is called *Le Diable Parle* (The Devil Speaks). Another picture represents the creation of the universe. Whatever we may ourselves believe, however artificial we may find the references to pagan cults, the fact is that the artist is also asking us to meditate on the bonds that connect each human being to the cosmos. Victor Segalen understood the breadth of the painter's metaphysical disquiet, particularly as revealed in *NOA NOA*. On the subject of this manuscript, which he had held in his hands, the poet alludes to a very famous picture by the painter that depicts a group of Maori men and women. Victor Segalen writes: 'We must therefore – and the painter is magnificently resolute in this – contemplate them under their savage enigma, the one that they will carry with them in their anticipated death: Where do we come from – what are we – where are we going?

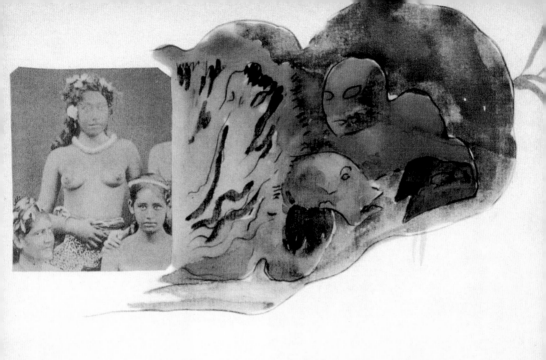

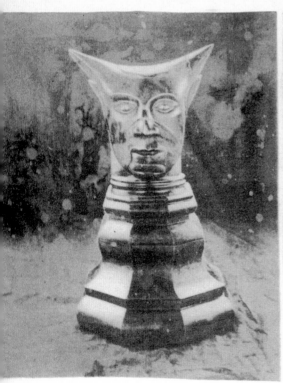

Songeries.
—

> Il est extraordinaire qu'on puisse
> mettre tant de mystère dans tant d'éclat.
> Stéphane Mallarmé (écouté)

En l'absence du Maître un Curieux —
ami attendu — pénètre dans l'atelier dont la porte entr'ouverte
invite; — et, dès le seuil, le visiteur reste immobile,
s'étonnant des murs.

Il s'était hâté de venir, passionnément désireux, peureux
aussi de voir l'œuvre nouvelle de Paul Gauguin, l'Œuvre
Tahitienne, fruit de trois années de travaux et de rêves,
là-bas, dans l'Île et, prudent, il avait à tous risques,
même à celui (d'où venait la peur) de ne pas comprendre,
longtemps, interdit à son imagination de faner à l'avance
la jouissance par d'indiscrètes inductions de probabilités;
il venait, l'esprit frais, les yeux francs, et voilà, devant
cette fête de jeunesse et de soleil à fonds inquiétants
jusque dans leur clarté, qu'il s'étonnait, qu'il
s'éblouissait de toutes ces splendeurs singulières
et calmes, simples, absolus où rien de notre occident
ne persiste —

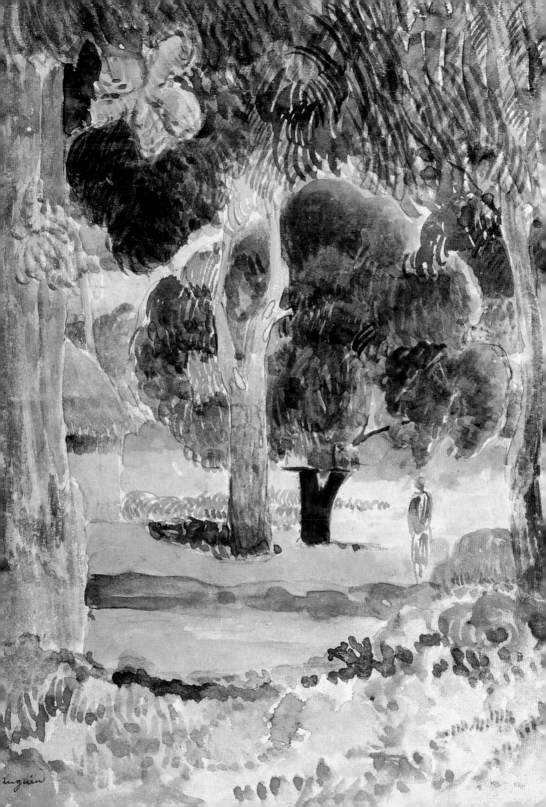

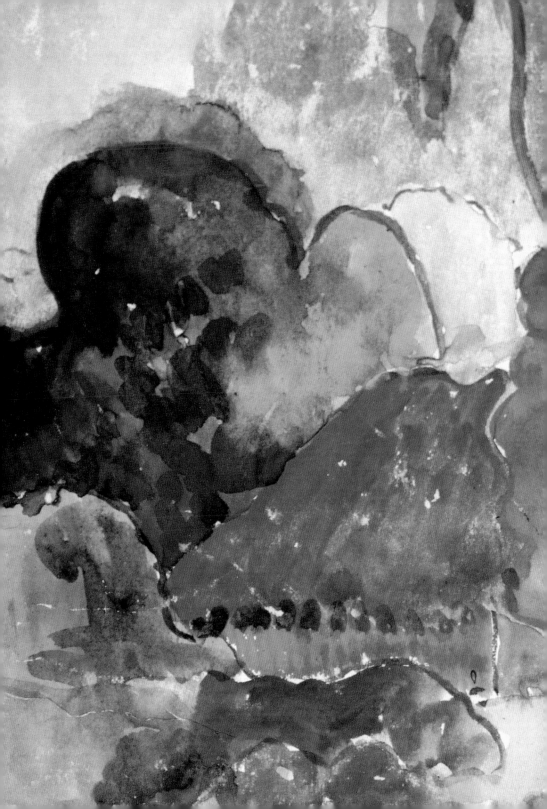

Il arriva que j'eus besoin, pour mes projets
de sculpture, d'un arbre de bois de rose; j'en
voulais un fût plein et large. Je consultai
Jotépha. —

Il faut aller dans la montagne, me dit-il.
Je connais, à un certain endroit, plusieurs
beaux arbres. Si tu veux, je te conduirai,
nous abattrons l'arbre qui te plaira et
nous le rapporterons tous deux.

Nous partîmes de bon matin
Les sentiers indiens sont à Tahiti assez
difficiles pour un Européen. Entre deux
montagnes qu'on ne saurait gravir deux
hautes murailles de basalte, se creuse une
fissure où l'eau serpente à travers des
rochers qu'elle détache, un jour que le
ruisseau s'est fait torrent et qu'elle entrepose
un peu plus loin pour les y reprendre un peu plus
tard et finalement les pousser, les rouler
jusqu'à la mer.

De chaque côté de ce ruisseau fréquemment
accidenté de véritables cascades, un semblant
de chemin parmi des arbres pêle-mêle; arbres
à pain, arbres de fer, pandanus, bouraos,
cocotiers, fougères monstrueuses, toute une

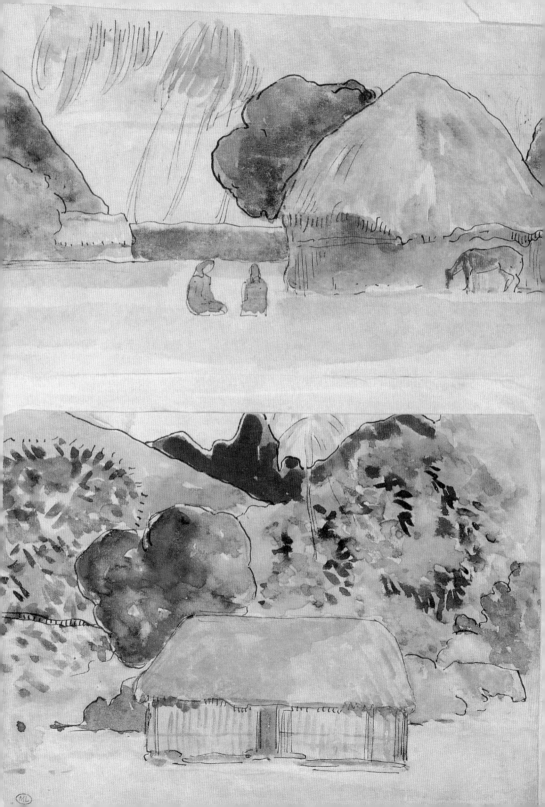

e tō'na ra oto, i te tāatā raa o te femna nei
I te atea ē „ I te atea ē rana'toa, tau mafatu e
te vivo te ute nei.

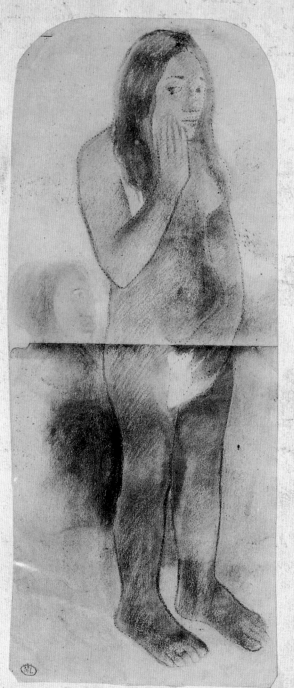

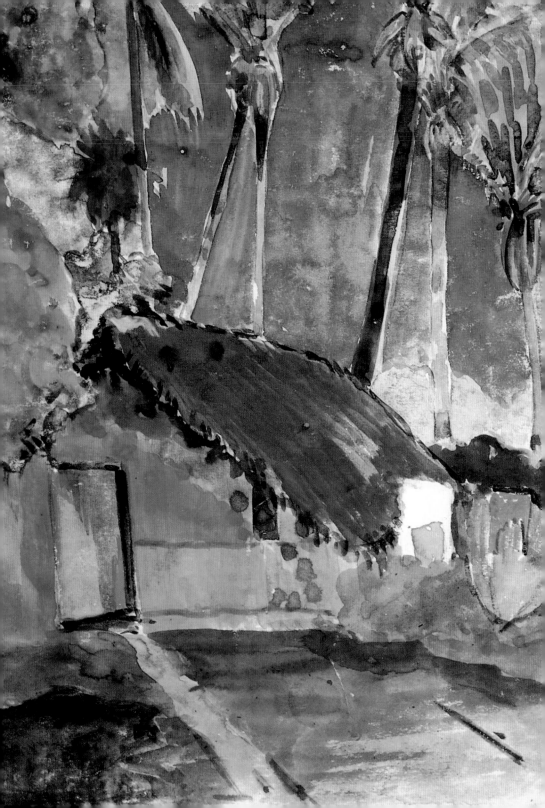

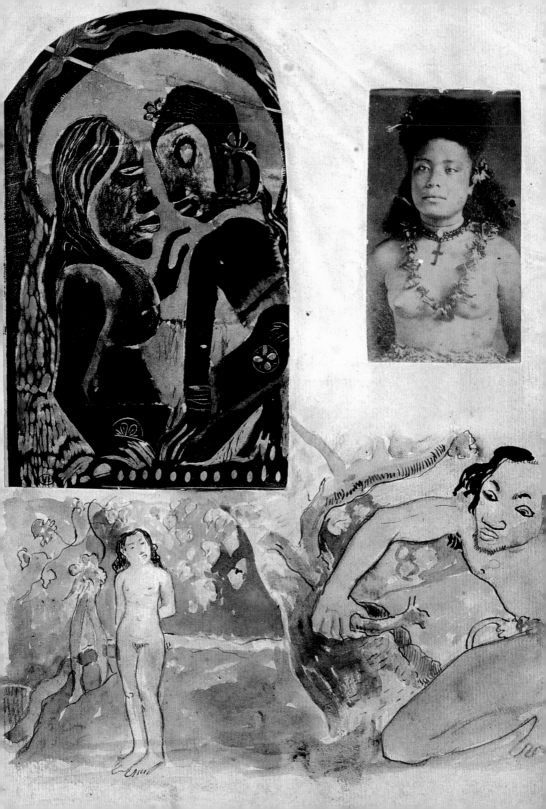

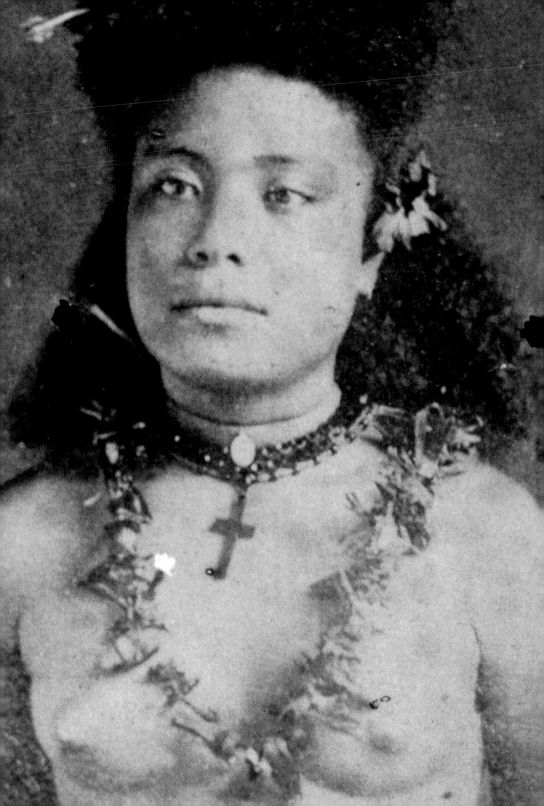

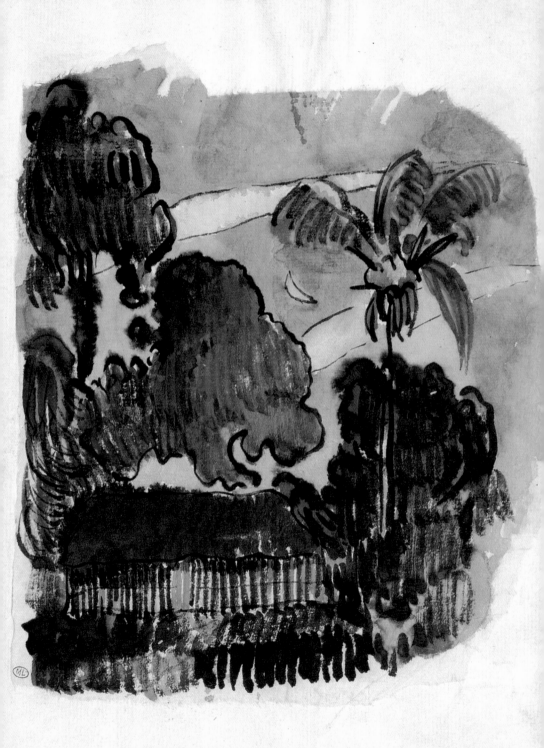

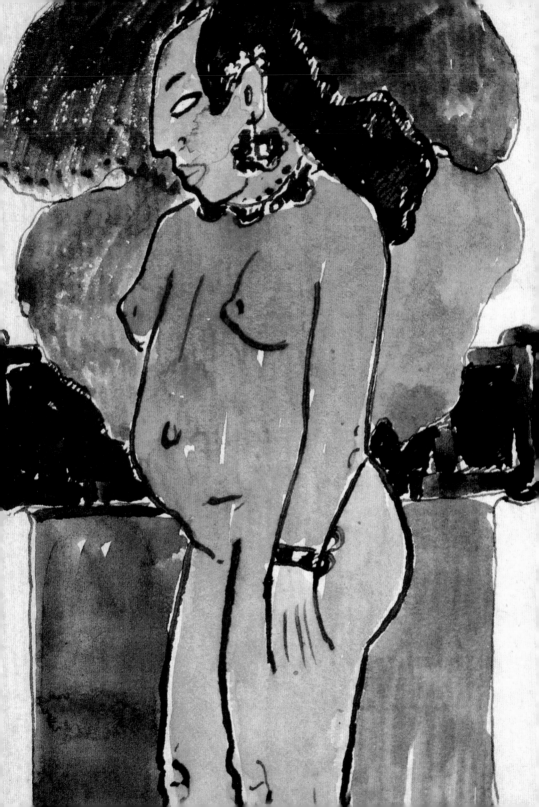

Chapitre IV –

Le Conteur parle –

Mes voisins sont devenus pour moi presque des amis.
Je m'habille, je mange comme eux. Quand
je ne travaille pas je partage leur
vie d'indolence et de joie, avec
de brusques passages de gravité.

Le soir, au pied des
buissons touffus que
domine la tête échevelée des
cocotiers, on se réunit par
groupes, – hommes, femmes
et enfants. Les uns sont de
Tahiti, les autres des Tongas,
puis des Aroraï, des Marquises.
Les tons mats de leur corps
font une belle
harmonie avec le velours du
feuillage, et de leurs poitrines
cuivrées sortent de
vibrantes mélodies
qui s'atténuent
en s'y

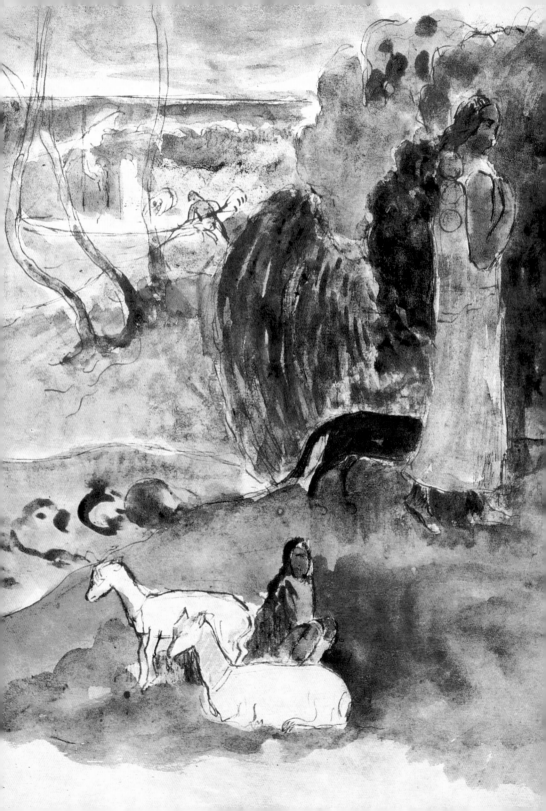

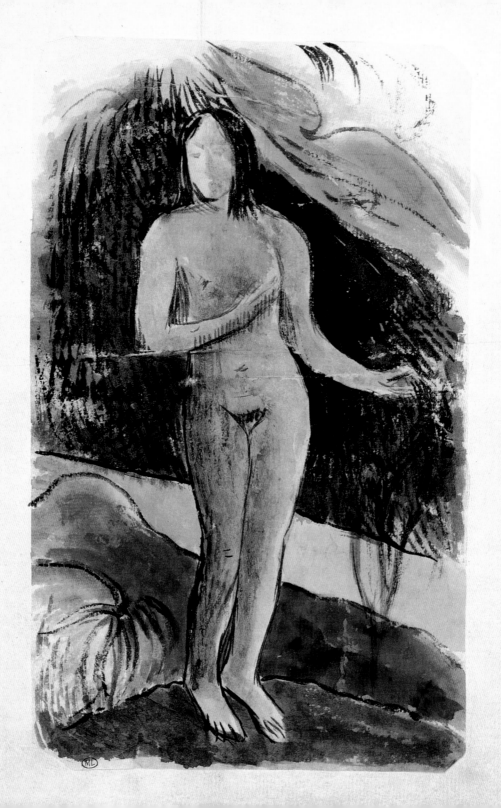

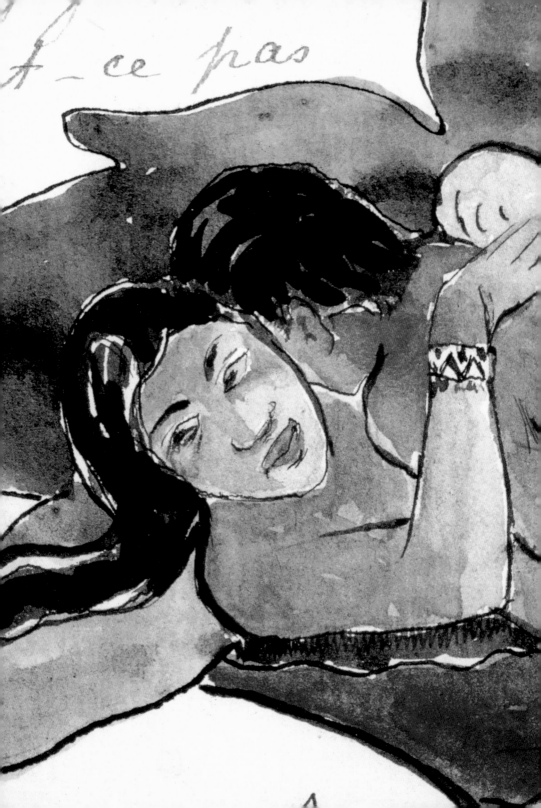

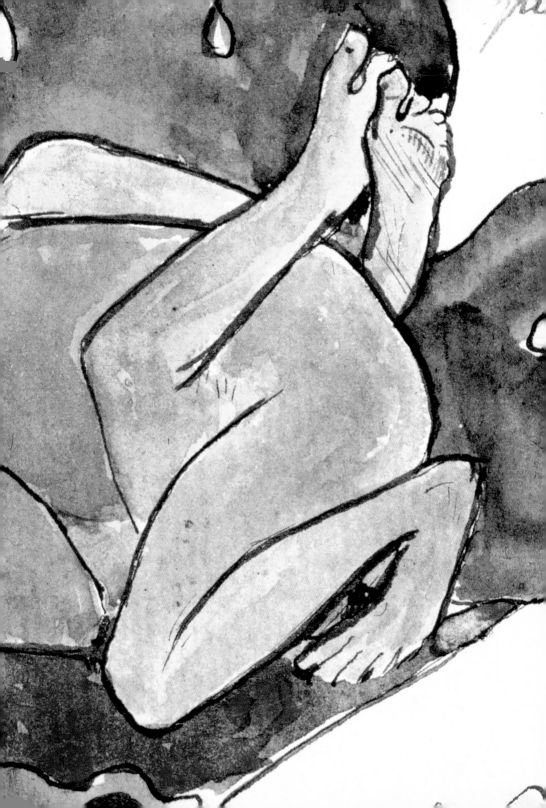

Parahi te marae.

Sommet d'horreur de l'Ile heureuse, là réside
Le Temple, lieu ouvert, morne, sauvage, aride;
Là sont les pieds des Dieux qui supportent le poids
Du ciel; là vient mourir la richesse des bois,
Tout en haut de l'Aroraï, cimier des cimes;
Là coulait, Autrefois, le sang pur des victimes
Où les vivants communiaient pieusement:
Et ce rite était cher aux Atuas cléments
Qui, gouvernant selon leur sagesse profonde —
Autrefois! l'effroyable expansion des mondes
Pardonnaient à la vie en faveur de la mort.

Alors l'Ile était grande et son peuple était fort,
Gardant du lieu sanglant où le soleil flamboie
Le secret de goûter une virile joie
A se plonger l'âme et le corps au flux vital
De la douleur. Ce fut le beau temps féodal.
Autrefois! Tahiti riait dans sa lumière,
Fille franche des eaux, délicieuse et fière,
Qu'enivraient de son sang les sacrificateurs.

au monde qui m'ait tenu ce langage, —
ce langage d'enfant, car il faut l'être,
n'est-ce pas pour s'imaginer qu'un

artiste soit quelque chose d'utile

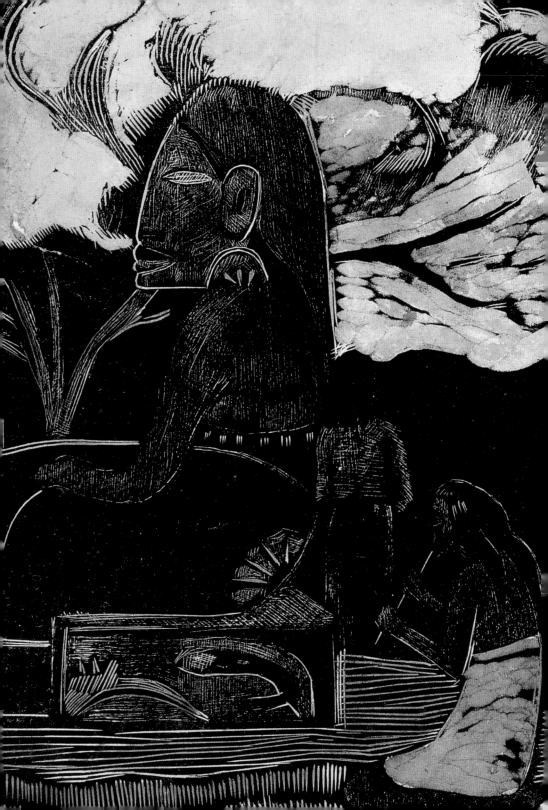

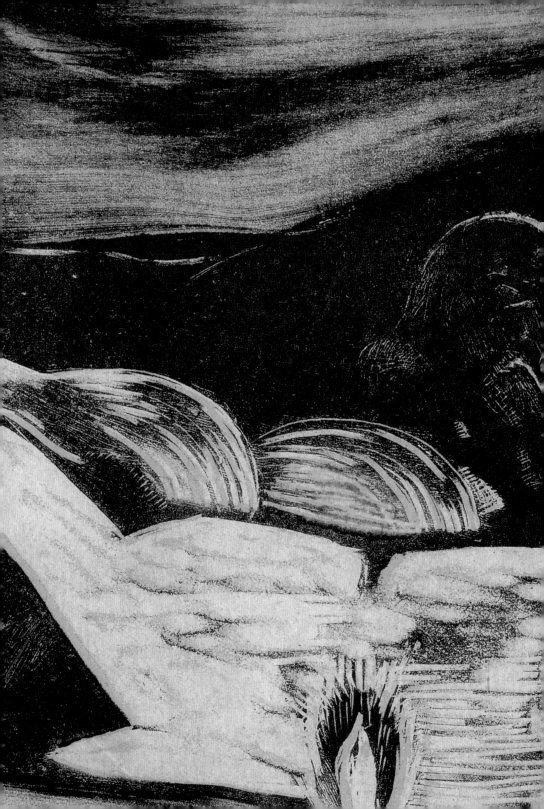

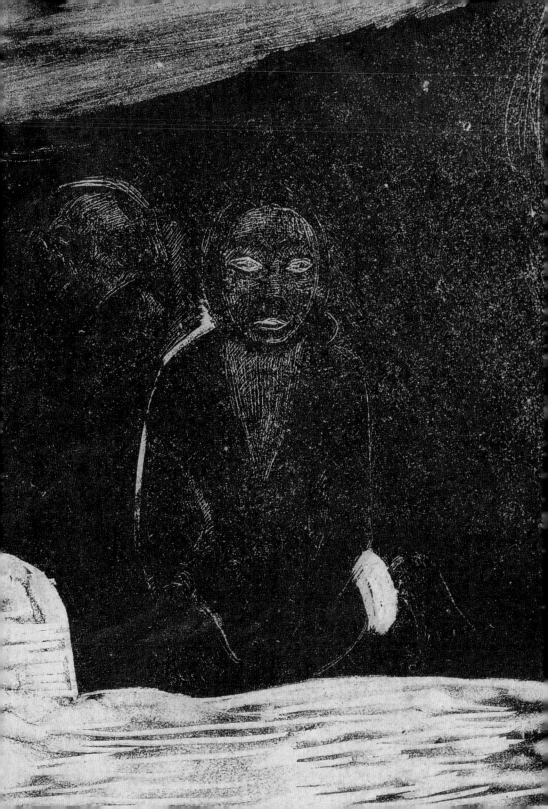

végétation folle, et s'ensauvageant toujours davantage
se faisant de plus en plus inextricable à mesure
qu'on monte vers le centre de l'Ile.

Nous allions tous les deux, nus avec le linge
à la ceinture et la hache à la main, traversant
maintes fois le ruisseau pour profiter d'un
bout de sentier que mon compagnon semblait
percevoir par l'odorat plutôt que par la
vue, tant les herbes, les feuilles et les fleurs
en s'emparant de tout l'espace, y jetait de
splendide confusion.

Le Silence était complet en dépit du
bruit plaintif de l'eau dans les rochers, un
bruit monotone, accompagnement de silence.

Et dans cette forêt merveilleuse, dans
cette solitude, dans ce silence, nous étions deux —
lui, un tout jeune homme et moi presqu'un
vieillard, l'âme défleurie de tant d'illusions,
le corps lassé de tant d'efforts et cette
longue et cette fatale hérédité des vices d'une
société moralement et physiquement malade !

Il marchait devant moi, dans
la souplesse animale de ses formes gracieuses,
androgynes : il me semblait voir en lui
s'incarner, respirer toute cette Splendeur
végétale dont nous étions investis. Et

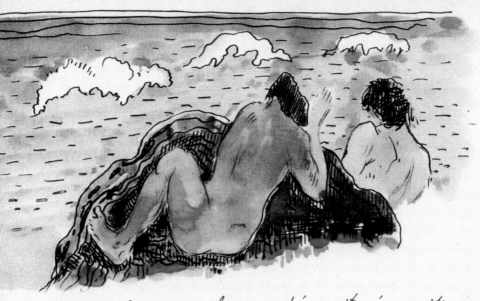

d'elle en lui, par lui se dégageait, émanait un
parfum de beauté qui enivrait mon âme, et où
se mêlait comme une forte essence le sentiment
de l'amitié produite entre nous par l'attraction
mutuelle du simple et du composé.

 Était-ce un homme qui marchait là
devant moi ?— Chez ces peuplades nues, comme
chez les animaux, la différence entre les sexes est bien
moins évidente que dans nos climats. Nous accentuons
la faiblesse de la femme en lui épargnant les fatigues
c'est-à-dire les occasions de développement, et nous la
modelons d'après un menteur idéal de gracilité.
A Tahiti, l'air de la forêt ou de la mer fortifie
tous les poumons, élargit toutes les épaules toutes
les hanches, et les graviers de la plage ainsi que les
rayons du soleil n'épargnent pas plus les femmes
que les hommes. Elles font les mêmes travaux

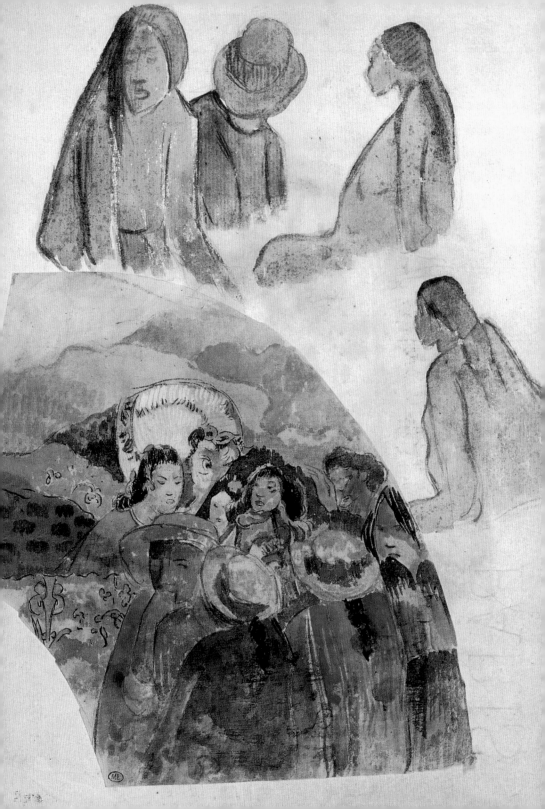

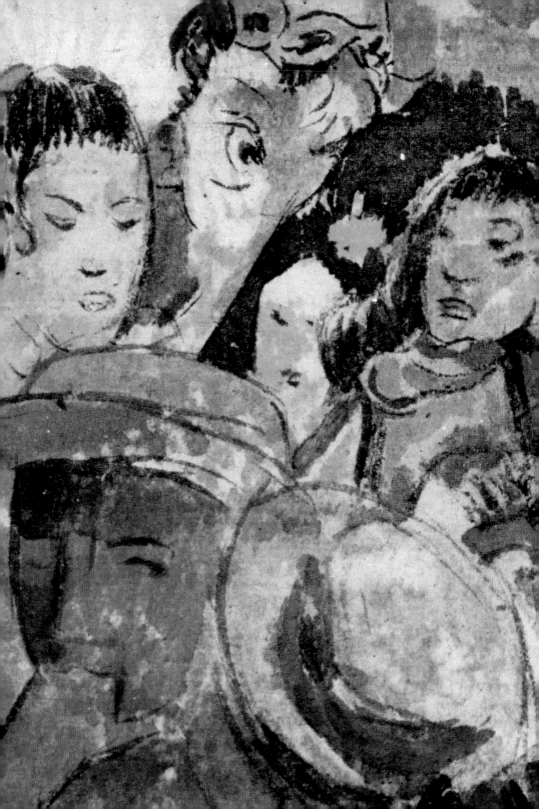

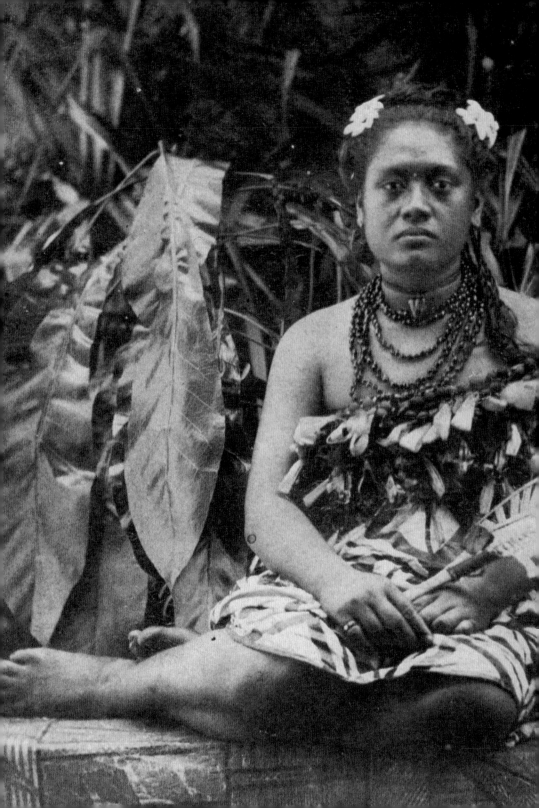

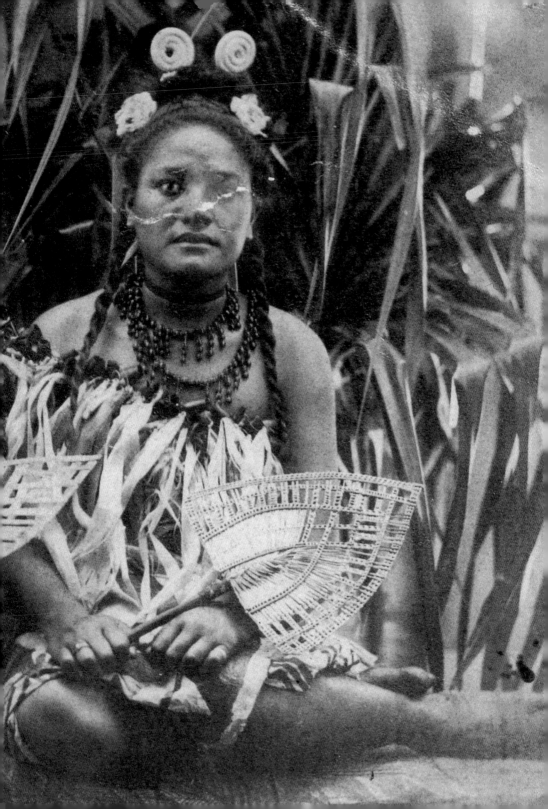

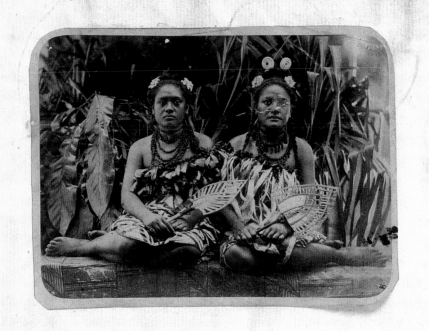

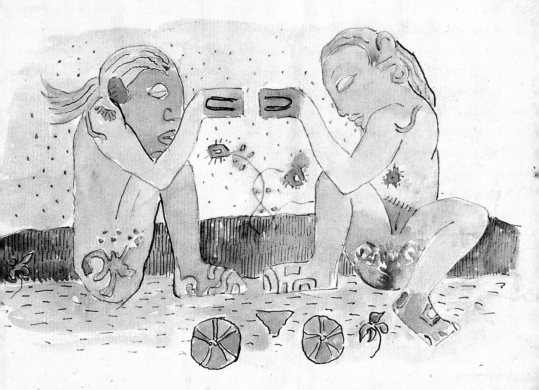

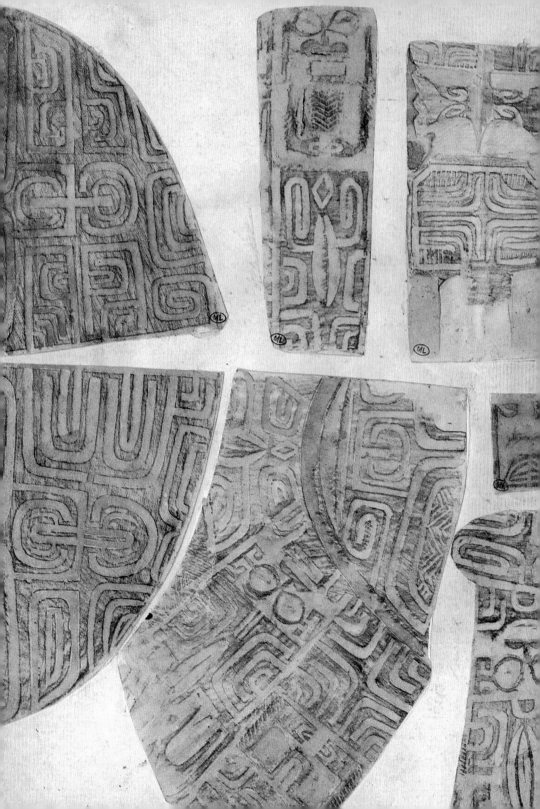

Chapitre XLIX.

Nave Nave Fenua

Petits tableaux et grands cadres

Episodes lyriques

La Nature commente les légendes

Prose et Vers

à venir

Souriant au soleil de rêve qui se lève
Ce continent de fleurs dans ces flots de feu d'or
—Eden— Eldorado, Floride, Labrador
Est ce un pays qu'on pourrait voir, ou bien mon rêve
Suggestion de la nature: ligne et couleurs — la Mer, les
Arbres (la forêt, la montagne — parfums, silence; Hina

Une idole massive impose à l'horizon
L'immémorial poids de ses lourdes saisons
Et les fleurs à ses pieds ne cessent pas d'éclore.
Et tout n'est que jeunesse, et tout n'est que splendeur

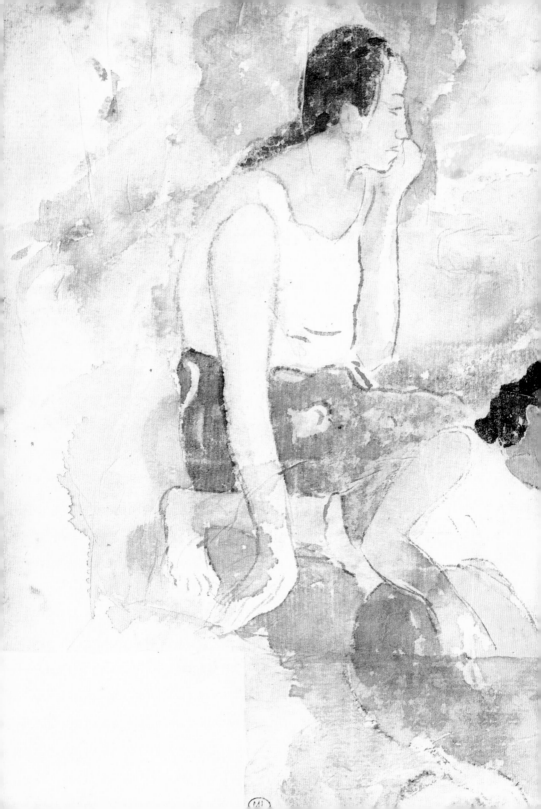

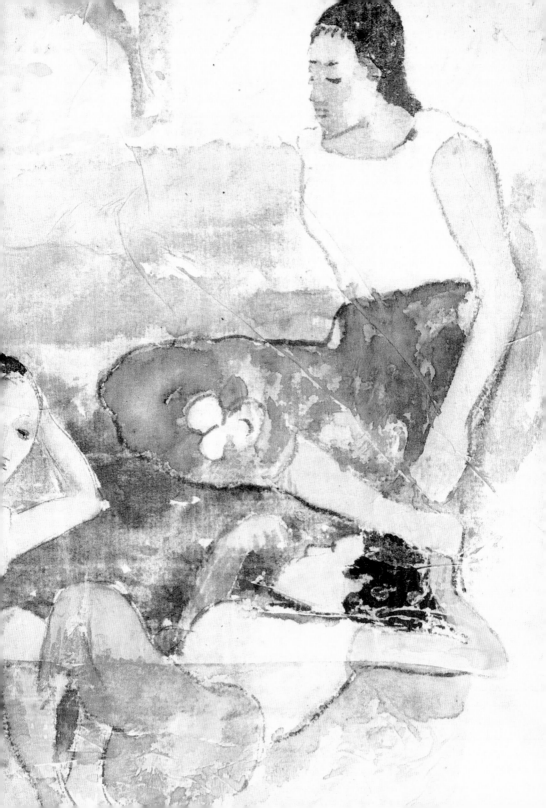

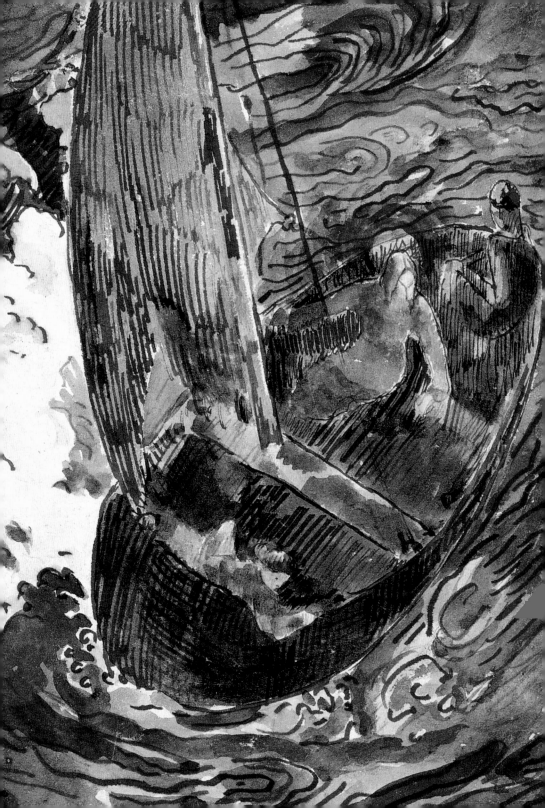

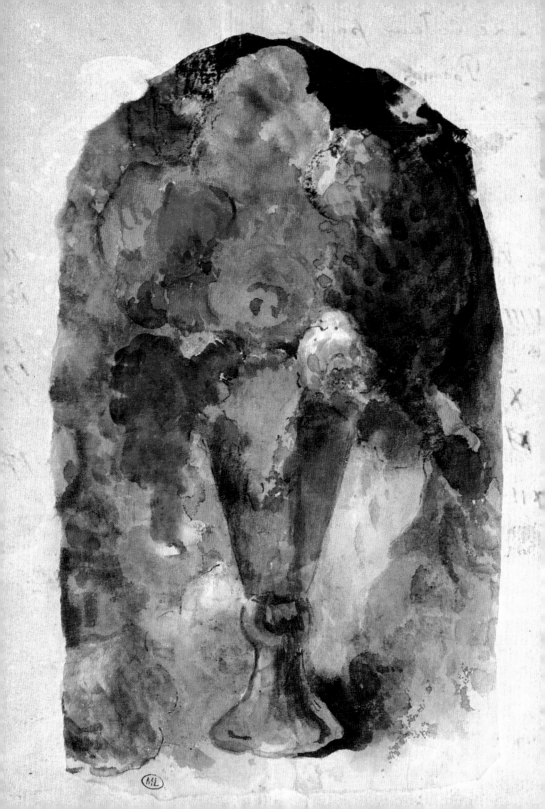

Le Conteur achève son récit

Il me fallait revenir en France. Des
devoirs [...] me rappelaient.

[...] terre
[...] de beauté"!

[...] réuni de quelques
[...] arrivée et
[...] sauvages ont
[...] lisé", bien
[...] de

[...] un moment
[...] dernière
[...] ourant
[...] et triste

toujours, mais calme, elle s'était assise sur
la pierre, les jambes pendantes effleurant
de ses deux pieds larges et solides l'eau salée.

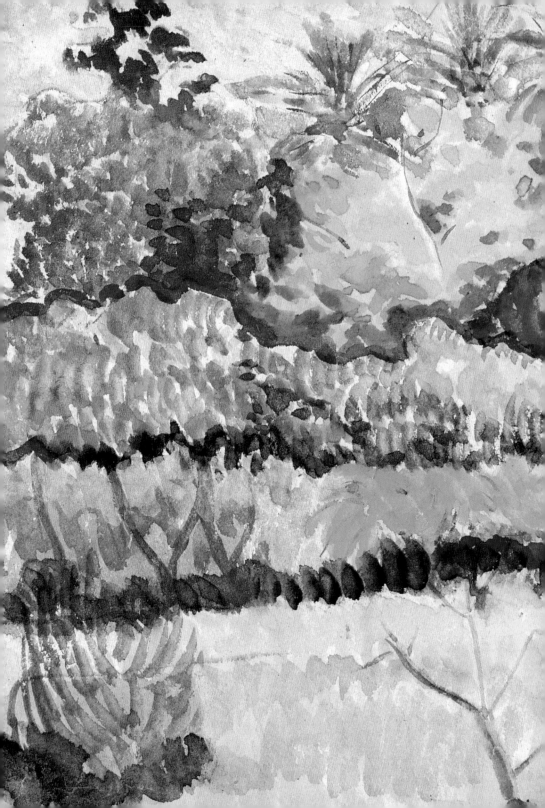

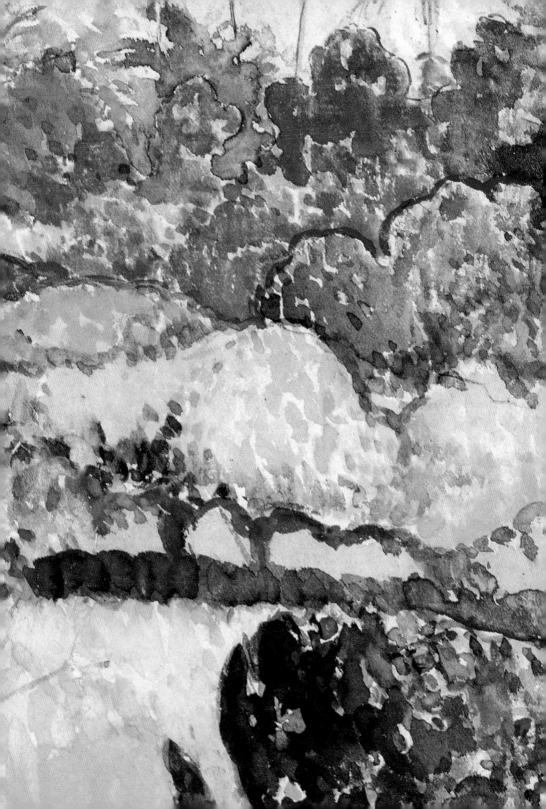

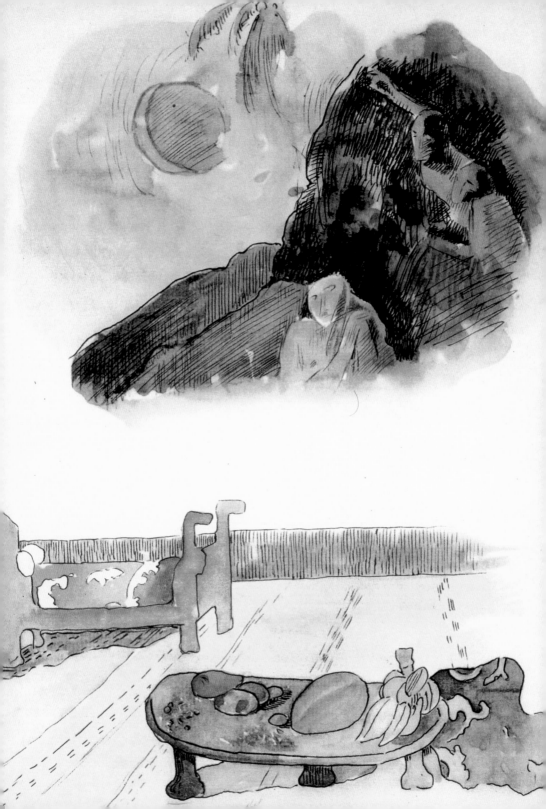

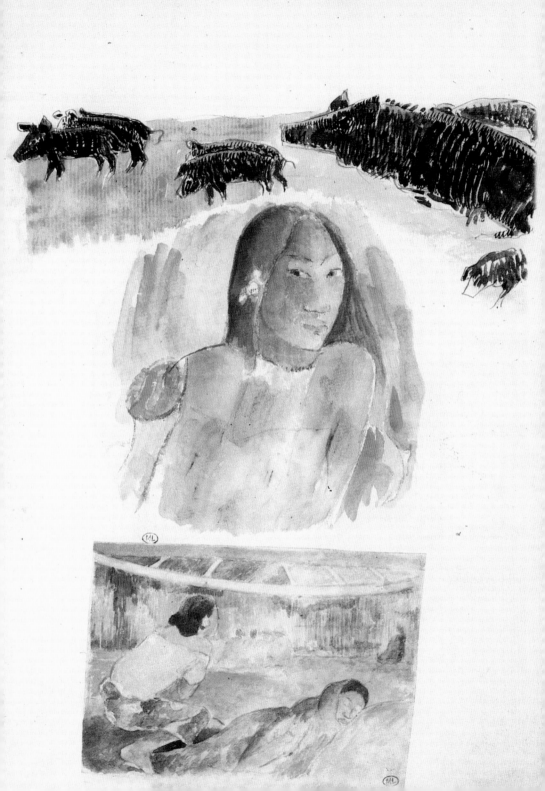

La paix rentra aussitôt dans mon âme.
J'éprouvai une jouissance infinie, autant spirituelle
que physique, à me plonger dans l'eau froide du
ruisseau.

— Toetoe (c'est froid) me dit-il

— Oh non! répondis-je

Et cette exclamation, qui dans ma pensée, correspondait
pour la conclure à la lutte que je venais de livrer
en moi-même contre toute une civilisation pervertie,
éveilla dans la montagne un écho sonore. La Nature
me comprenait m'entendait et maintenant, après la
lutte et la victoire, elle élevait à son tour sa grande
voix pour me dire qu'elle m'accueillait comme
un de ses enfants.

Je m'enfonçai vivement dans le fourré,
comme si j'eusse voulu me fondre dans cette immense
nature maternelle. Et mon compagnon, près de moi,
continuait sa route, avec ses yeux toujours tranquilles.
Il n'avait rien soupçonné: moi seul portais le
fardeau d'une mauvaise pensée.

Nous arrivions au but. À cet endroit
les murs escarpés de la montagne s'évasaient, et
derrière un rideau d'arbres enchevêtrés s'étendait
une sorte de plateau, très caché mais que mon
guide connaissait bien. Une dizaine d'arbres de
bois de rose étendaient là leurs vastes ramures,

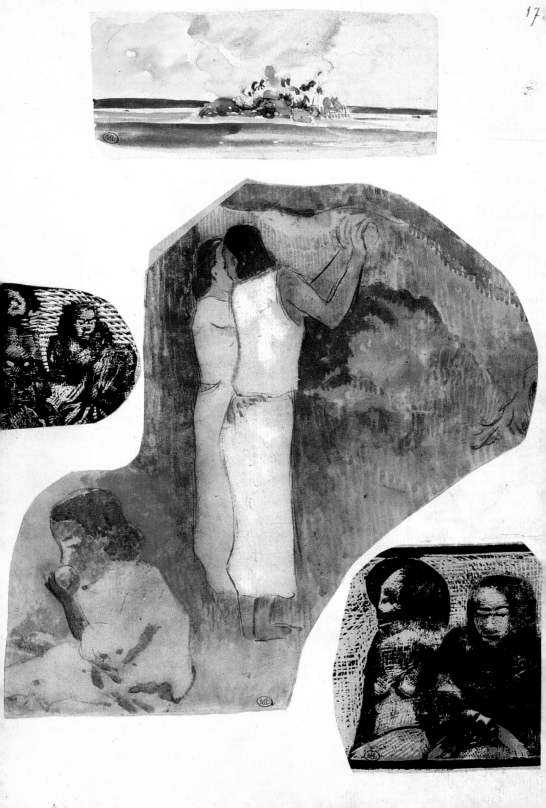

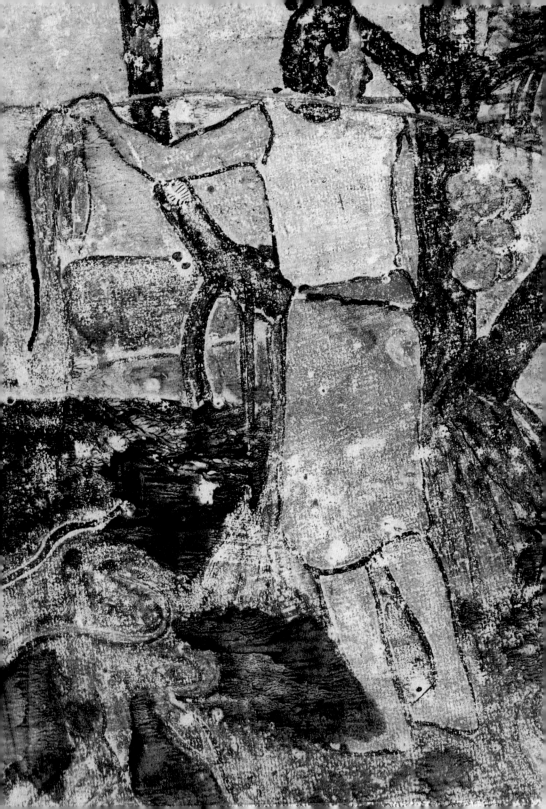

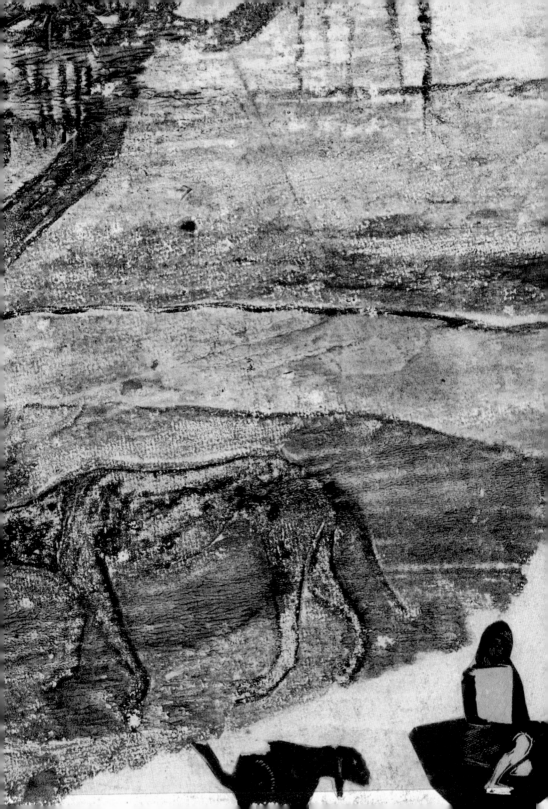

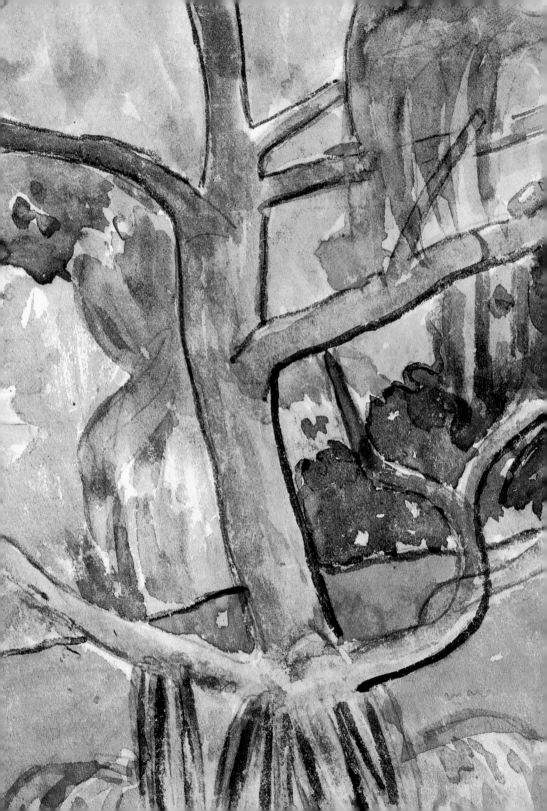

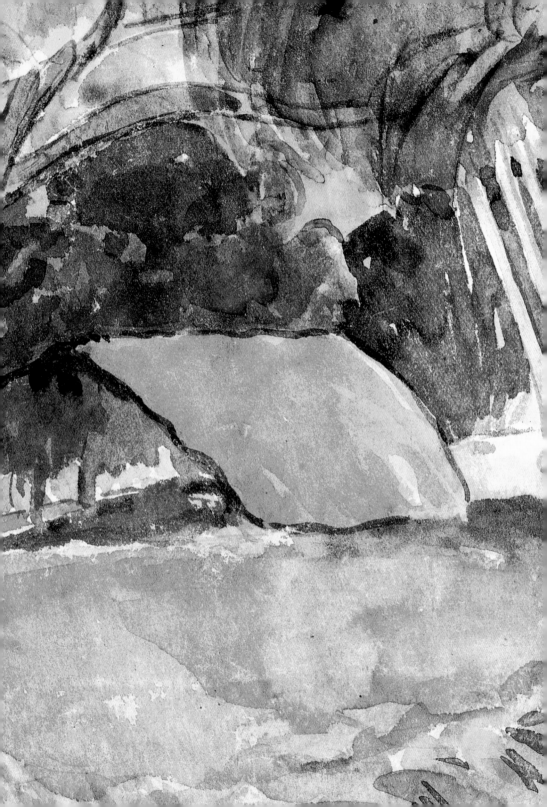

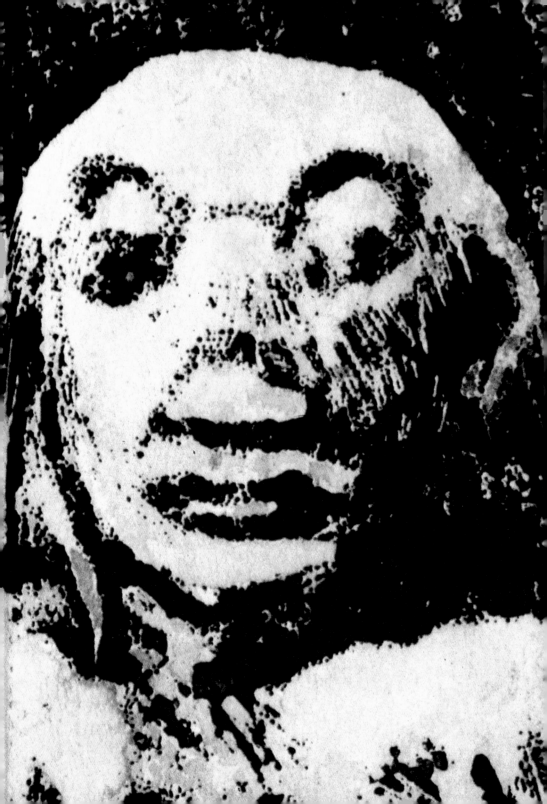

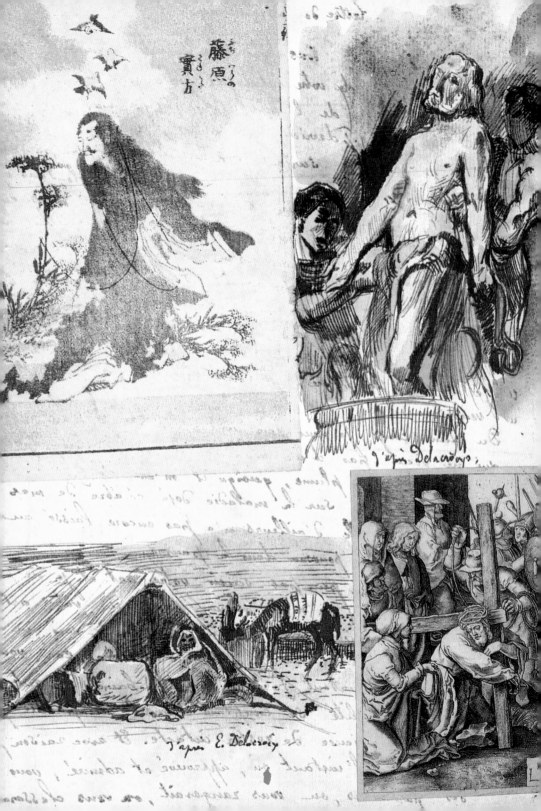

THE NARRATOR FINISHES HIS STORY

I had to return to France.
Pressing family duties called me back.

Farewell, hospitable land, delicious land, home of freedom
and beauty! I leave after two years, twenty years younger, more uncouth
therefore than on arrival and yet more educated. Yes, the savages have taught
many things to the old civilized man – many things, those illiterates, about
the science of living and the art of being happy.

When I left the quay, at the moment of taking to the sea,
I looked for the last time at Tehura. She had cried through several nights.
Now weary and still sorrowful, but calm, she was seated on the stone, legs
dangling, skimming the salt water with her two broad, strong feet.
The flower that she had earlier been wearing at her ear had
fallen on to her knees, now wilted.

Here and there, others like her, tired, silent, without thoughts,
watched the heavy smoke of the ship which bore us all away, lovers of a day.
And from the ship's bridge, through the spy-glass, it seemed that
for a long time we could still read on their lips
this old Maori declamation:

'You, gentle breezes from the South and from the East, who
come to frolic and caress each other above my head, make haste to run
together to the other isle; there you will find the one who has
abandoned me, seated in the shade of his favourite tree.
Tell him that you saw me in tears.'

From Paul Gauguin, NOA NOA

La fleur qu'elle portait auparavant à son oreille était tombée sur ses genoux, fanée.

FIN

Gauguin, *NOA NOA*

Paul Gauguin copied out by hand the text that he entitled NOA NOA *and which was the result of his 'collaboration' with Charles Morice, in Paris in 1894. He took the manuscript to Tahiti and then to the Marquesas Islands. On certain parts of the pages, and on pages that he had left blank, he then made watercolours and woodcuts. He also pasted in photographs. This work was carried out between 1896 and 1903, the date of his death.*

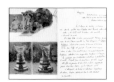

The photograph of three Maori women and the two photographs of a pagan idol are accompanied by a painting in which two cursorily drawn faces may be discerned. They have the appearance of ghosts emerging from the confluence of two expanses of colour. The proximity of the idol and the naked bodies evokes the return to 'primitive' nature, necessary for man to rediscover his soul, perverted by civilization.

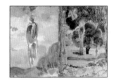

Gauguin calls upon the Romantic tradition of landscapes in which Nature – in this case, soil and trees heavy with foliage – forms the essence of the picture. A small human silhouette invites the viewer to meditate on the immensity of Nature. The page on the left details the silhouette, lightly sketched among radiant colours.

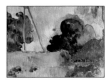

A broad landscape without any human or animal figures. But, as in all Gauguin's pictures, the colour is spread out in flat, uniform zones. The colours are so vivid because they are highly saturated with pigment; The intensity is in the eye of the painter and in our own: a gaze that makes the visible world more intensely present to us.

Two Maori dwellings, doubtless similar to the one that Gauguin inhabited in the Marquesas, as described by Victor Segalen. The painter was constantly attentive to the way in which the Maori people fitted their daily lives within this environment, which was, for him, exotic. He tried to live his own life in conditions close to theirs.

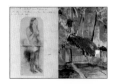

This landscape is very important for Gauguin's treatment of colour. The intense blue of the sky and the concentration of the dark-hued pigments turn it into a kind of compact, solid mass. There is no recession here towards a blue horizon, as classical art had dictated since the time of Leonardo da Vinci. Everything visible jumps out at at the viewer with equal strength in each of its parts.

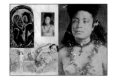

This page seems to mark three stages in the painter's spriritual life: the photograph of a naked woman whose body is decorated with jewels and flowers; a woodcut showing a pagan goddess and idol; and a scene which might, for us, evoke Adam and Eve in Paradise. If he can preserve his primitive characteristics, man also keeps alive his bonds with the divine, revealed in the great diversity of legends in all civilizations.

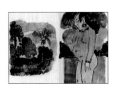

These two pictures brilliantly demonstrate the primary role given to colour by the 'modern' painters of the end of the 19th century. The Fauvism of Henri Matisse attests to the great importance of this novelty for the art of our century as a whole, including a great deal of abstract art. Classical art lent primacy to line, to that which can be measured and narrated. By stressing the role of colour, attention was drawn to what Vincent Van Gogh called 'the terrible human passions'.

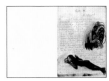

The reclining figure looking towards us is the same woman who was presented lying on a bed in the 1893 painting entitled *L'Esprit des Morts Veille* (The Spirit of the Dead Watching), in the Goodyear Collection in New York. This oil painting precedes the watercolour. Remembering it, Gauguin reversed the position of the woman: here, her face is to our left; in the painting, it faces to our right.

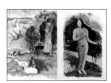

In the text of *NOA NOA*, Gauguin returns a number of times to the beauty of Maori men and women. He describes it at length, stating how much the expression and posture of these men and women reveal life in harmony with nature: a 'primitive' harmony, both because nature remains largely savage and because neither the things nor the people are perverted by Western civilization.

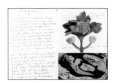

Gauguin had called his home 'the house of ecstasy'. He saw the Polynesian islands as a place of a new and happy eroticism, the home of a people whose culture allowed a greater sexual liberty than the cultures of the West. For him, art is essentially erotic: a sensual relationship with the perceptible world.

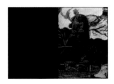

The religious beliefs and rites of the Maoris introduced objects that we might call 'idols'. Their forms were doubtless symbolic, but these were not 'sculptures' representing some divine figure. In his texts, Gauguin speaks of the insidious role of the Christian missionaries who set about destroying their culture. The 'god' that he imagines here owes a great deal to the African sculptures that were beginning to be known in Europe at the end of the 19th century.

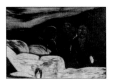

A recumbent statue, ghostly figures, a black sky crossed by lights. Gauguin's spiritualism attempts to capture the spirit of all forms of polytheism: the world alive with a conflict of forces, some light, some dark – like life and death.

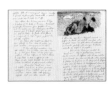

Nudity and the sea's rolling waves. In ochre, blue and white, Gauguin pursues his dream of a recovered Paradise.

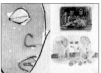

Left: The work of the painter is evident in these 'details': simplified forms, monochrome expanses of colour, a black outline delimiting the hues so that they lose none of the sensuality accentuated by the fluidity and transparency of the watercolour.
Right: While some zones of colour preserve the effects of the transparency of the watercolour, others — ochre, blue, red and green — present apparently impenetrable surfaces to the eye. Gauguin draws contrasting and opposite effects from colour.

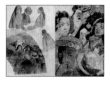

The juxtaposition of the photograph of two Maori women and a painted depiction of two bodies which turns them into a kind of idol for a primitive cult reveals what 'primitivism' is for Gauguin: simplified and hieratic forms, flat expanses of colour, and space formed by a tiered arrangement of coloured zones. The figure on the left shows this 'simplification' of visual devices.

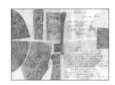

Left: Decorative motifs. For the cultures we call 'primitive', the 'decorative' is something other than a high level of visual harmony with which to decorate objects. What is at stake is far more serious: nothing exists for man other than the marks of his activity. Right: This page gives us an idea of the way in which Gauguin worked on his manuscript. During his last stay in the islands he complemented the text of his book with notes, both words and sketches, made the same day.

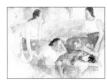

Unlike the preceding page, the picture is composed as strictly as one that could be painted on canvas. These four female bodies, whose arrangement constitutes a 'scene' in a landscape, can be compared with a number of other works by the painter, for example *Femmes de Tahiti* (Women of Tahiti) of 1891; which can be seen in the Musée d'Orsay in Paris.

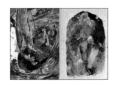

Left: A boat at sea, its reddish brown standing out almost vertically on the blue sea. Space, for Gauguin, could no longer be presented 'in perspective' as it was in classical art. This new space treats the near and the distant in almost identical ways, presenting all aspects of the visible with equal intensity to his eyes.
Right: A bouquet of flowers. Gauguin was painter of colour and in his works it is the strength of this that yields the form.

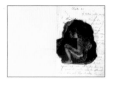

This woman is undoubtedly Tehura, whose sadness at parting is discreetly concealed.

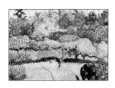

This floral landscape is a reminder of how close Gauguin was to the Impressionists. He diverges from them in the longer, more suggestive brushstroke of the form, and in his composition, based on broad, layered bands.

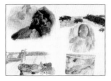

Man in the cosmic world in which appear stars, animal life, human beauty and the scenes and places of everyday life. Art has always dealt with the present, however humble, while at the same time dealing with what is most enigmatic for us in the universe.

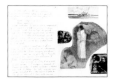

The effect of this page – a mixture of techniques, subjects and perspectives – demonstrates the unique creativity of Gauguin, as it does his range of talents.

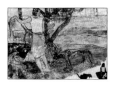

Gauguin, with his spiritualist preoccupations, was no less attentive to the daily life of the Maoris and their 'primitive' customs. This 'primitivism' enables us to meditate on human destiny. A man brings back the fish that he has caught, he is walking in a landscape of sand and sea, crossed by the axes formed by the branches of the tree. This pictorial space is composed in four bands of horizontal colour superimposed on one another. To the painter's eye, everything is nearby, or rather nothing is distant.

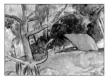

Sometimes the landscape darkens. A dullness seems to be falling over the colours, but is this merely an effect of the twilight? We might also remember Paul Cézanne saying, towards the end of his life, 'The evening of the world is falling.' Gauguin was soon to die in the Marquesas.

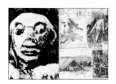

Left: 'Paul Gauguin fécit' is written at the bottom of the left-hand picture. The painter picks up the old formula that had been the artist's signature since Jan van Eyck's *Arnolfini Wedding* in 1534. Right: Gauguin painted the figure of Christ and biblical scenes a number of times. To the reproduction of an image of an episode from the ascent to Calvary, he adds a naked Christ 'after Delacroix', who rehabilitated colour-based art in the 19th century.

The painted picture has hidden part of the writing. Verbal thought fades into the background, because a painter thinks with his eyes. This ochre woman in her red dress is surrounded by a double halo. The human figure in its 'primitive beauty', as embodied in this woman, is, for the painter, like that of a god or an emperor in medieval illuminated manuscripts, occupying the centre of a mandorla surrounded by concentric lights. Gauguin's words, hidden here by the picture, are shown on the facing page.